Window Seat

To A New World

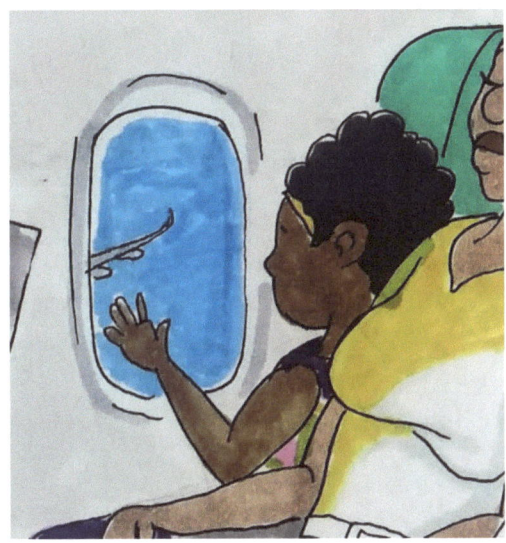

Written by
Victor Akpan

Illustrated by
Malik Whitaker

Copyright © Malik Whitaker LLC

All rights reserved. This book or any portion thereof may not be reproduced or used in any manner whatsoever without the expressed written permission of the publisher except for the use of brief quotations in a book review of scholarly journal.

First printing: 2019
ISBN:
Malik Whitaker LLC
PO Box 5763
Hillside NJ 07205

www.malikwhitaker.com

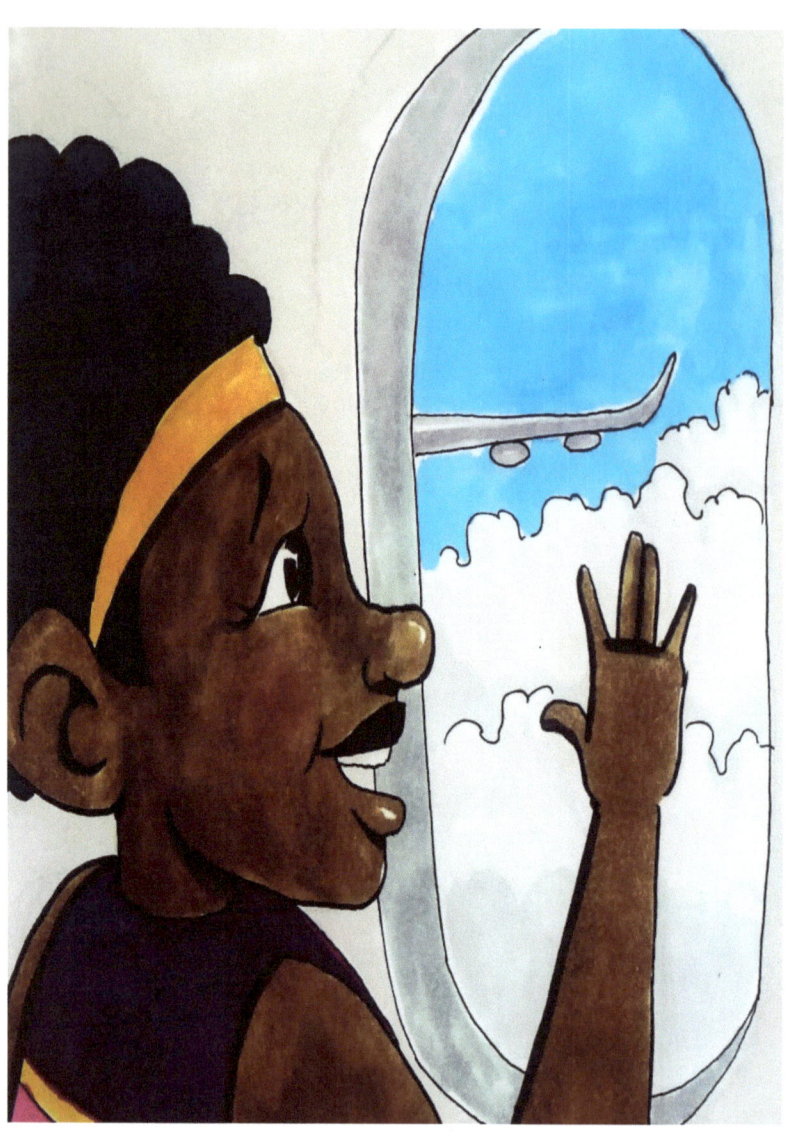

"BISI! BISI! We are almost there!"

As Bisi looks out the window of the tiny Embraer ERJ170, she contemplates what awaits her in this new world. She looks out the window, pondering in exhaustion about her family, old school, neighbors, neighborhood, friends and

the world she was leaving behind in Nigeria. Would they like her in this new city? she wondered. Will they take her wrongly? Will she be a misfit? These questions swirled in her young mind as she looks around her, taking in all the new cultures, behaviors and new racial looks. She has never been around so many people of different races, most of whom were Caucasian.

She looks down at the teddy bear on her lap that her grandmother had given her at the airport. She was told it used to be her mother's, given to her by a missionary nurse on the day of her birth.

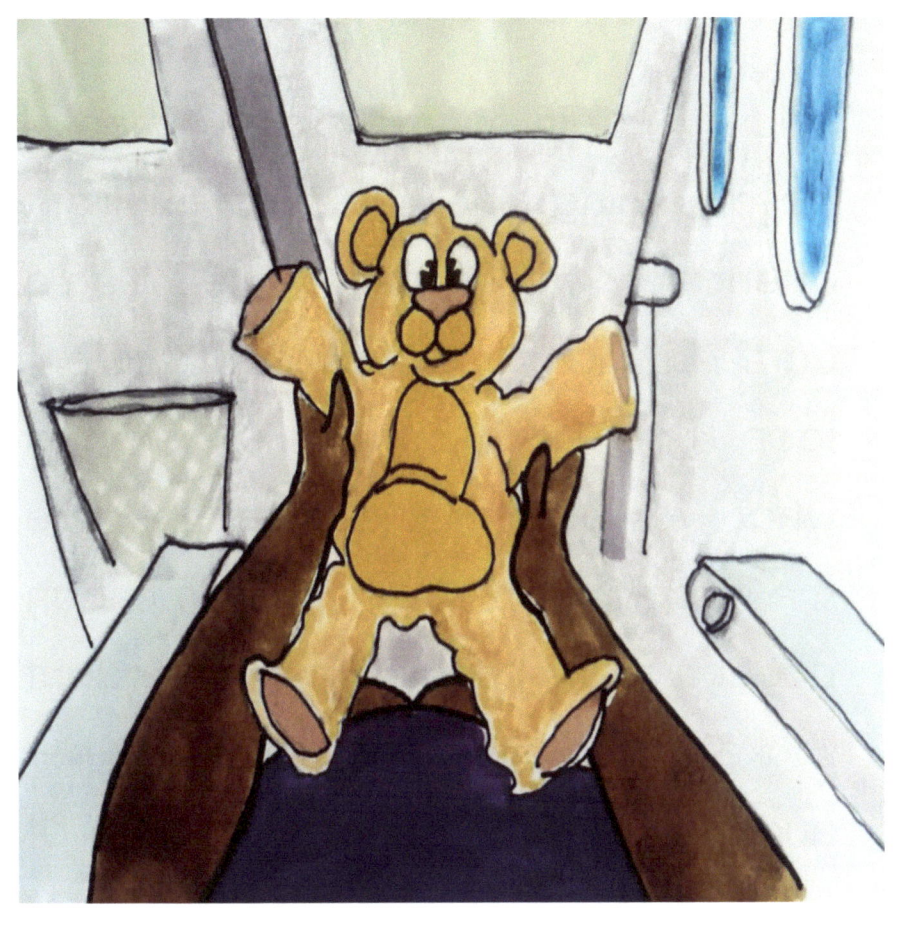

"Excuse me, would you like a snack before we land?" said a soft-spoken

voice interrupting Bisi's mental daydreaming. She looks up at the flight attendant standing next to them with a cart. Bisi had a look of confusing on her face. She could barely understand what was being said to her because she was not familiar with the American accent of which the flight attendant spoke with. Noticing her confusion, her aunt, sitting next to her, looked up at the flight attendant, smiled and responded on her behalf;

"Yes please, thank you."

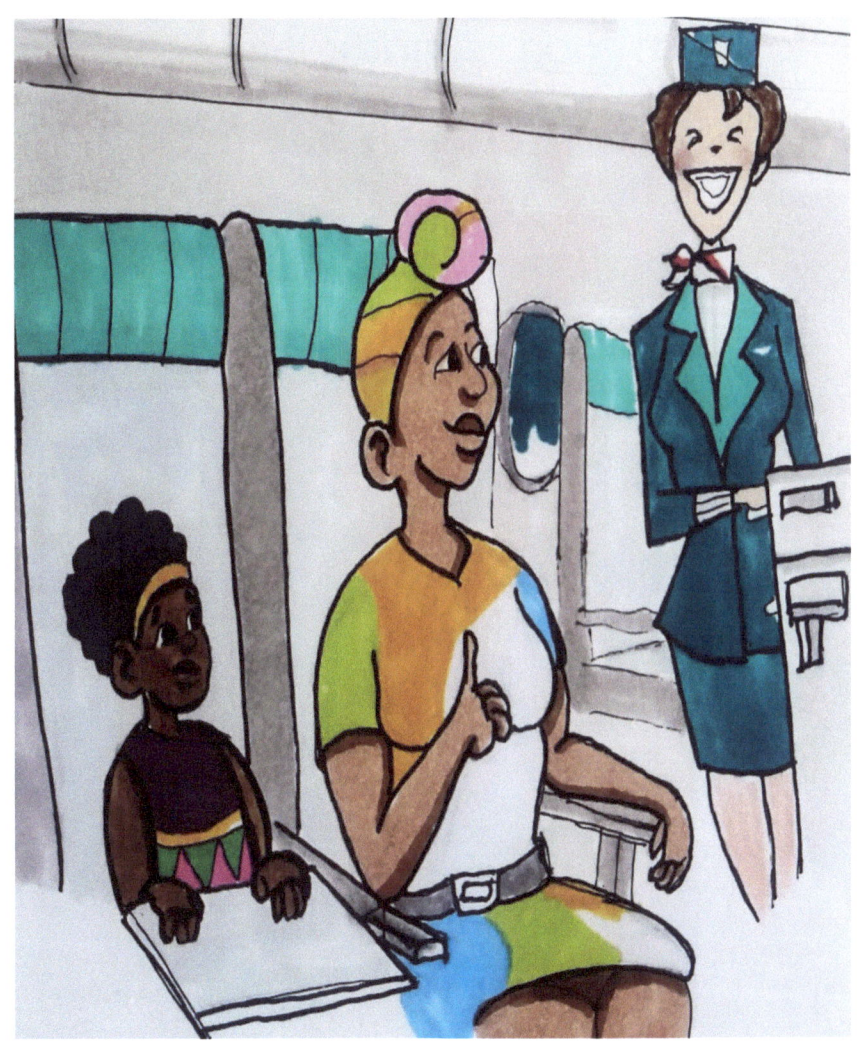

Bisi was handed a snack box. Most of it's contents looked very colorful and

had cartoon characters on the packaging.

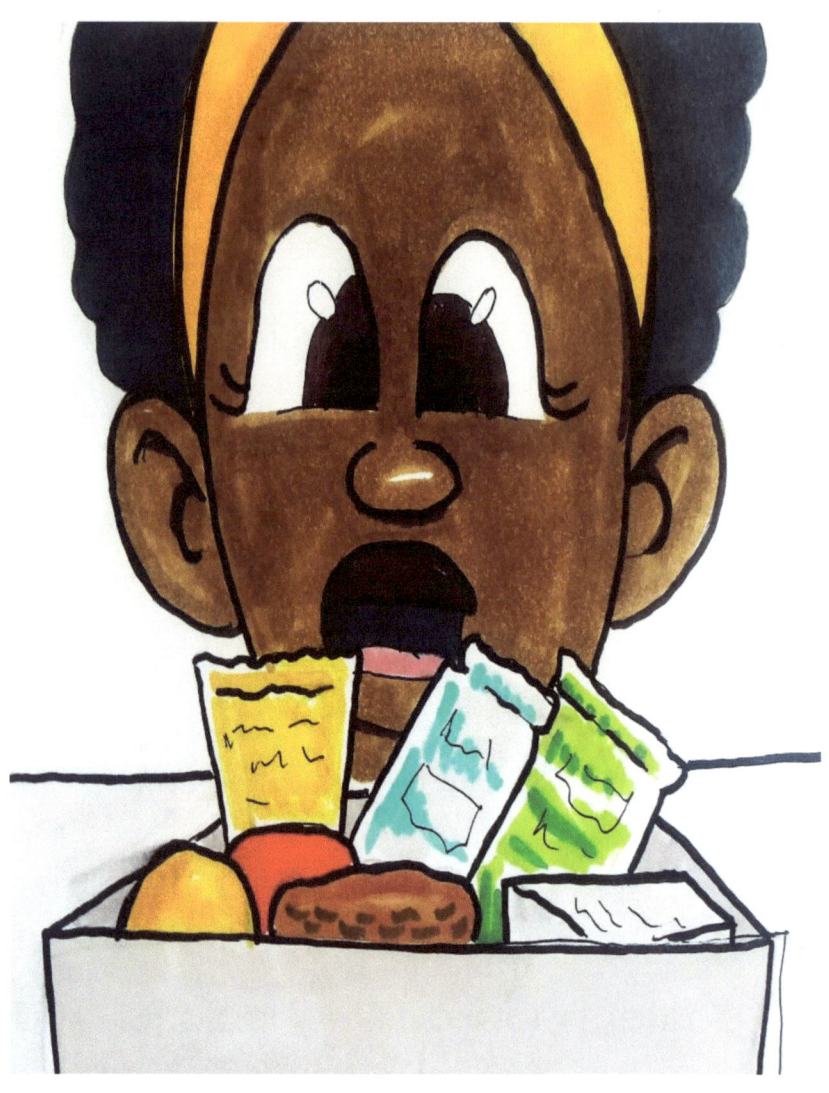

Her aunt, noticing her confusion started laughing.

"Hahahaha, my dear Bisi. Why are you looking at it so funny? It's ok, it's just American snacks and candies."

Picking up one of the snacks, she said;

"This one is called a fruity cereal bar, and this is called Jell-O fruit. Try it. I'm sure you will like it. Here, let me help you."

She unwraps the bar for her and opens the juice box for her as well. Bisi picks up the snacks and tries them one after

another. They tasted very sweet and chewy, although the texture of the Jell-O was a bit weird. It somewhat tastes like saturated Akuma; a morning dish made of corn starch, condensed milk and sugar which her mother use to make for breakfast and it was serviced with fried bean cakes called Akara.

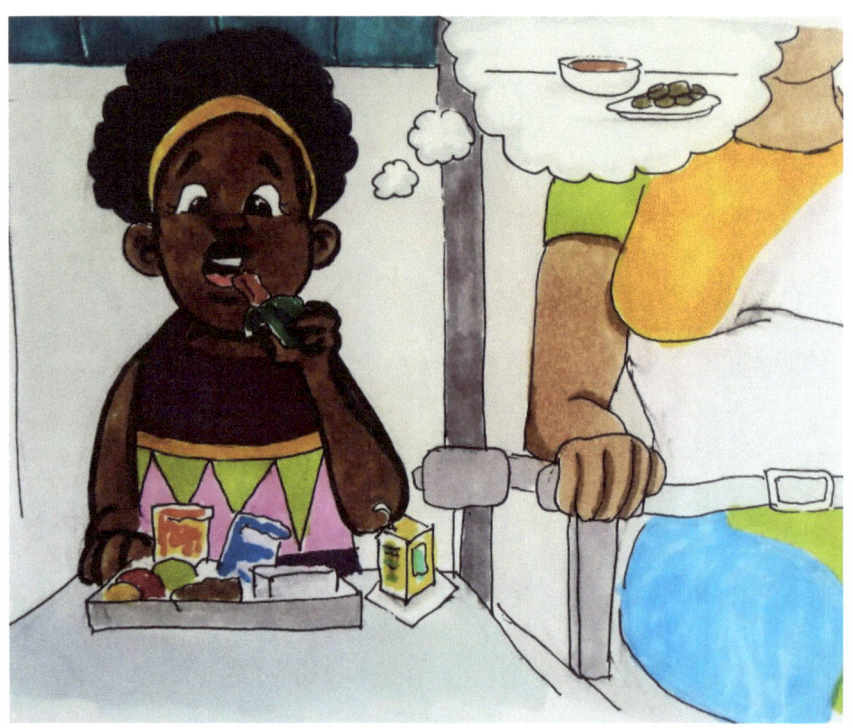

The plane starts to suddenly jolt up and down followed by a loud ding sound as the seatbelt sign above them illuminated. The captain's voice comes out of the speakers from above them stating that everyone should have their seatbelts fasten because they were now going through turbulence. Bisi's auntie turns to her to explain what was happening.

"This is almost like going over bumps on the road when driving but it's in the air. Don't worry my dearie. We'll be fine!"

Bisi remembers the bumpy roads of Ijebu-Ode. She recalls her last road trip to the airport with her grandmother, her aunt and uncle in the minivan.

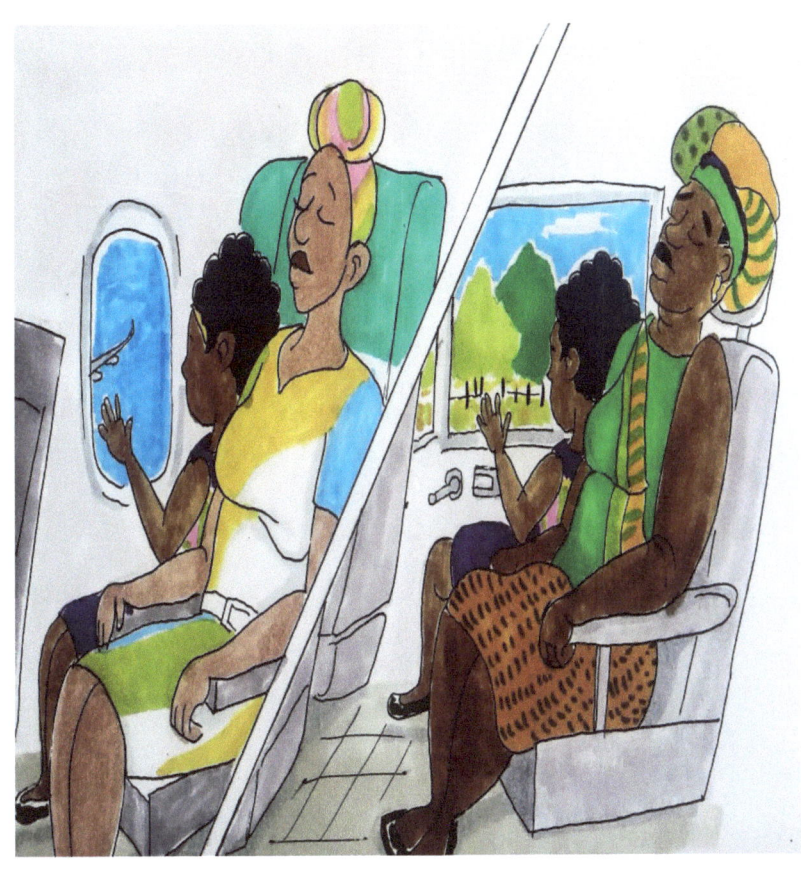

The night air was more chilled and somber. It was a bittersweet moment for them all, knowing she was on her way to the USA with her aunt. She remembered the entire ride as her

grandmother held her close, rocking her and singing her favorite lullaby. She also remembers her later whispering in her ear in their native language,

"My beautiful angel, I will miss you so much. You are about to embark on a wonderful journey to a land that holds promises. When you get there, please don't forget about me. I will always love you and have you always in my heart. Make sure to keep in touch. Write to me often my child, write to me often."

Her grandmother then pulls her closer as she continues humming her sweet

lullaby while the minivan rocks up and down on the dusty, bumpy road on its long journey to the airport. In that hour it seems like time stood still. That night, under the African stars, Bisi's young mind fades into the calming melody of her grandmother's voice singing.

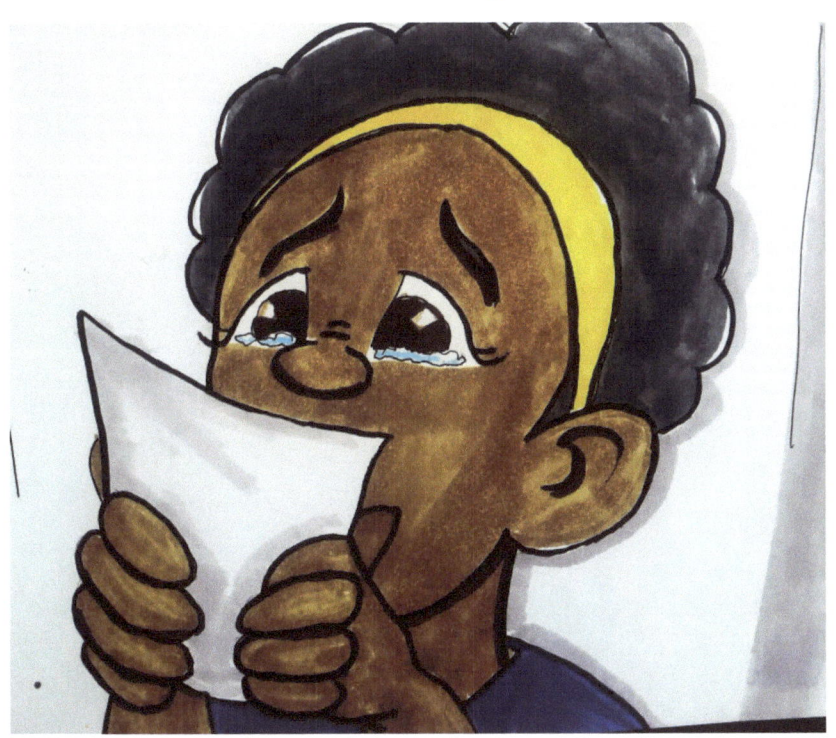

Bisi pulls out the picture of her parents from her pocket and soon the tears start to well up in her eyes. Her aunt turns to look at her crying and saddened to see her niece's grief, she draws her closer to her.

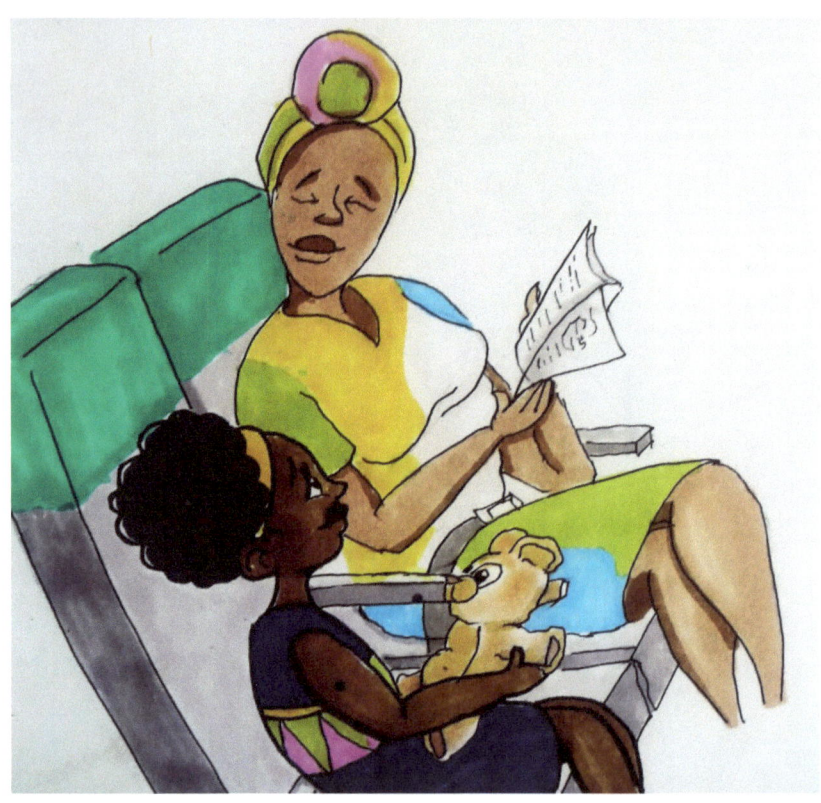

"My dear Bisi, I also miss them so much. Just remember that they love you and are always watching over you no matter where you are."

She looks up at her aunt, and for a moment admires the similar resemblances she had with her father. They both share that beautiful smile she missed seeing on his face when he smiled at her and called her his 'precious heartbeat.'

Abisi then realize that the turbulence had stopped, just as her aunt had promised.

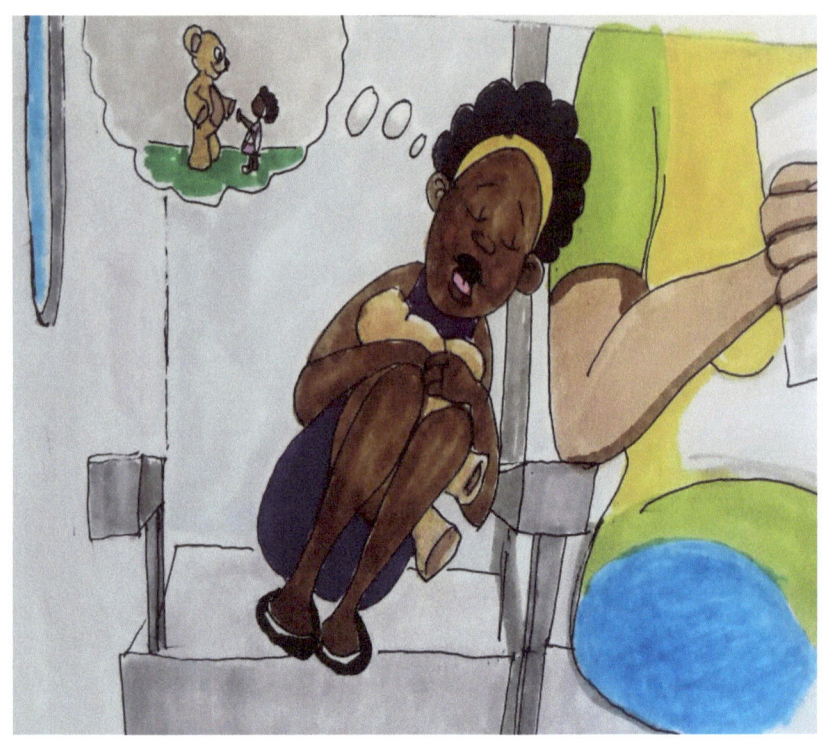

Suddenly, something deep down inside made her feel everything was going to be okay. Snuggling on her teddy bear, she looked down at it as she began to feel sleepy. It then seemed to magically speak to her. It reassured her

in a subtle whisper that spoke to her heart.

"Yes Bisi, everything will be ok."

Abisi closes her eyes and soon falls asleep on her aunt's shoulder. As she slept, she dreamt of her parents hugging her and telling her how much they love and miss her. Her aunt turns to look at her beautiful niece sleeping peacefully and smiles.

She eventually wakes up as the plane began its final decent for landing. She was nervous about what the future held. Twenty-three hours after going

through customs in Nigeria, she remembers getting on a plane for the first time. It was a very big plane and she was shocked by its size and how something so big and heavy could take off and fly. They eventually landed in Amsterdam only to then connect to another big plane hours after going to Detroit. Nine hours later, they landed and now they were on their final leg of the journey to Springfield in a tiny airplane.

Concerns of her future began to flood her young mind again.

Will she be able to assimilate in with all these white people?

Will they accept her for who she is?

Will she be able to make new friends?

Will she be able to cope with the new culture shock she was already experiencing?

She looks down at her teddy bear, wishing it had the answers to her questions. She turns to look out the window at the light from the city of Springfield on the round below as the plane began to get lower and lower.

An hour later, they landed. With her aunt holding her hand, they both exited the airplane to begin her new life in America.

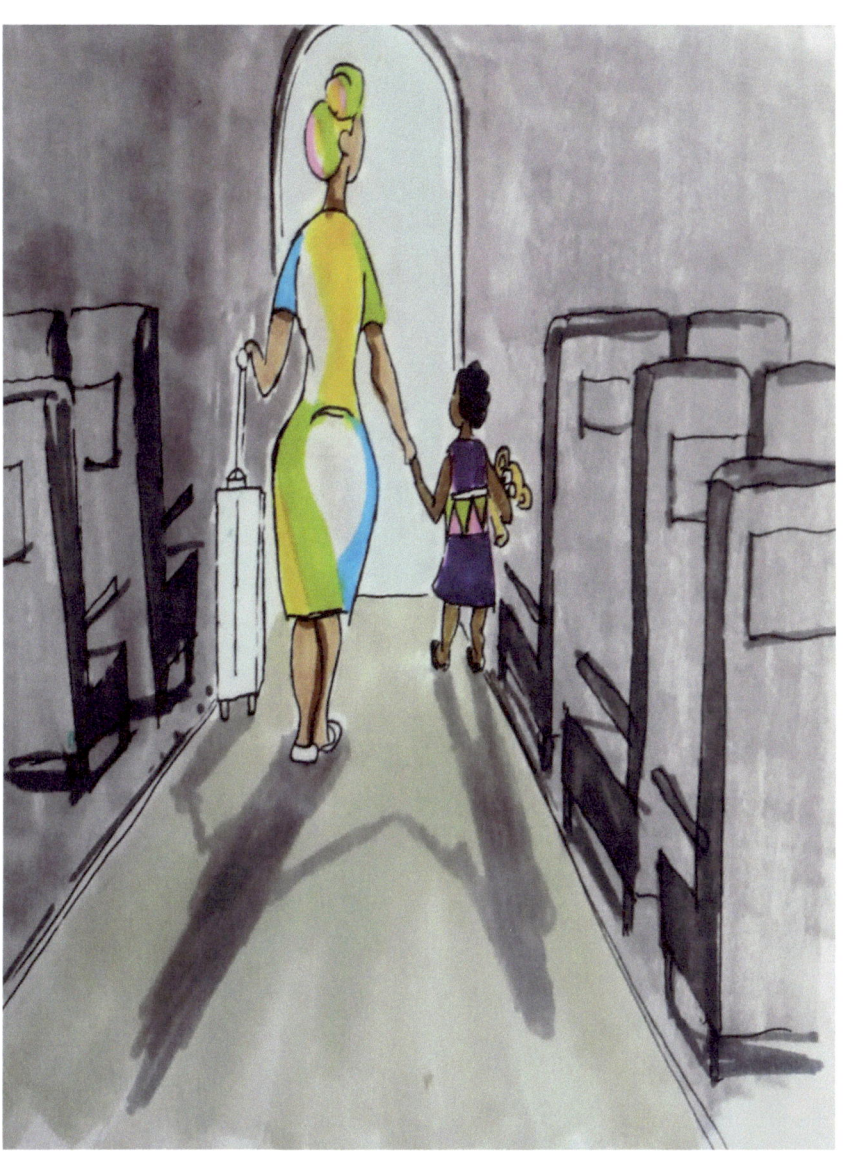

. . . . Onto the next adventure!!

Ijebu-Ode

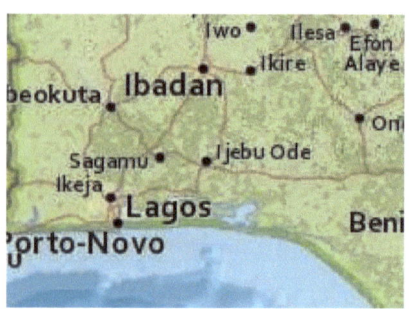

Abisi's hometown is in Ogun state, southwestern, Nigeria. It is a major collecting station for many products such as kola nuts, kernels, palm and cocoa oil. The town's biggest industry is printing and publishing companies. The trade for the local Ijebu people is in oranges, corn, cassava and palm produce. The towns people are also great at ornamental iron work and masonry. Ijebu-Ode is mostly known for its Ojude-Oba festival. It is a day set aside to celebrate the king, commemorate the culture attire and traditions of the Ijebus and founding fathers. The festival features horse displays, dancing competitions and beautiful culture attire.

The town also has Ogun State College of education, Muslim and Christian primary teacher training colleges and government vocational school and a hospital for infectious disease.

About the Author:

Victor Akpan is a long time Newark resident with a strong passion for creative writing and narrating the African migration story using his Nigerian background. 'A Window Seat to A New World' is his debut publication with global distribution. Victor enjoys the countless hours he spent with his family while in Nigeria and this shared family love led him to write about and shared his heritage though his writing. He's currently working on several other children's books and adult book projects to be release soon.

About the Artist:

Malik Whitaker is a visual artist born and raised in Newark NJ. He is a muralist, illustrator and arts educator who spends most of his tie creative art and workshops. Malik has illustrated several books and publications and uses his art to affect change in his community. He has a strong passion for story telling through his art and has partnered with several authors to illustrate their stories. More can be found on the artist and his work at www.malikwhitaker.com

www.ingramcontent.com/pod-product-compliance
Lightning Source LLC
Chambersburg PA
CBHW041118180526
45172CB00001B/320